THE
BOOK
of HUGS.
by Attaboy

For Annie,
who encourages
such nonsense.

EXCUSE
TO SMELL
YOUR
COCONUT
SHAMPOO
HUG.

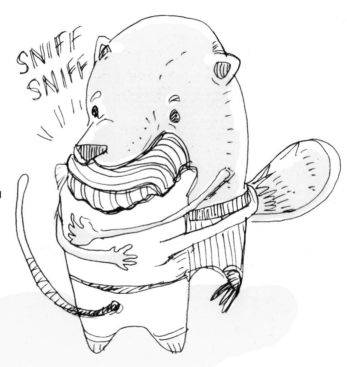

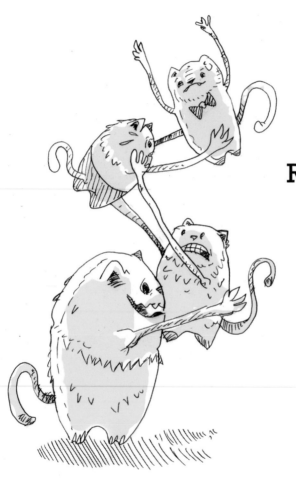

CHAIN
REACTION
HUG.

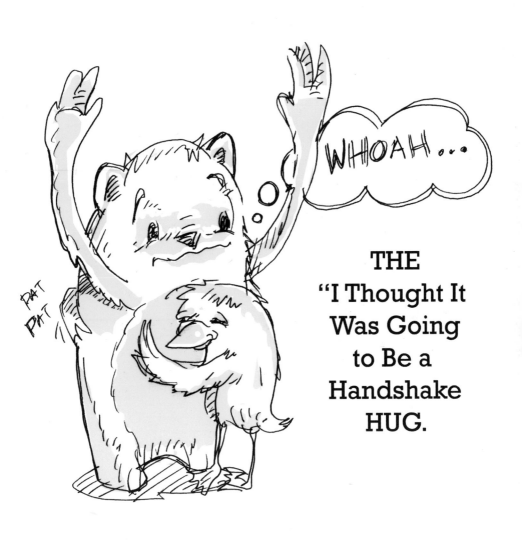

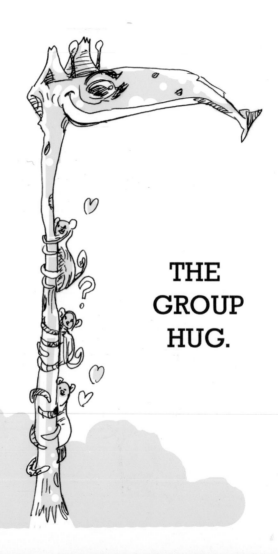

THE
GROUP
HUG.

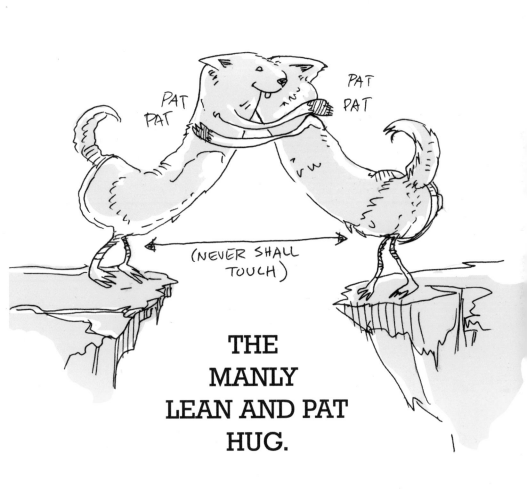

THE
"You'll Have
to Do"
HUG.

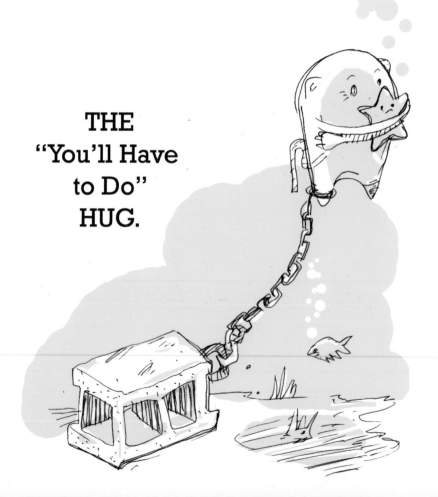

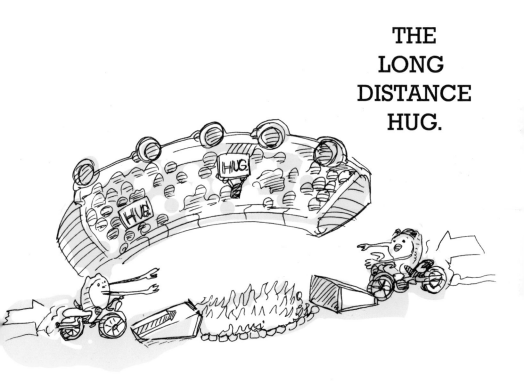

THE
LONG
DISTANCE
HUG.

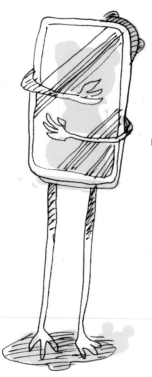

THE
"Fairest of
Them All"
HUG.

THE MISMATCHED HUG.

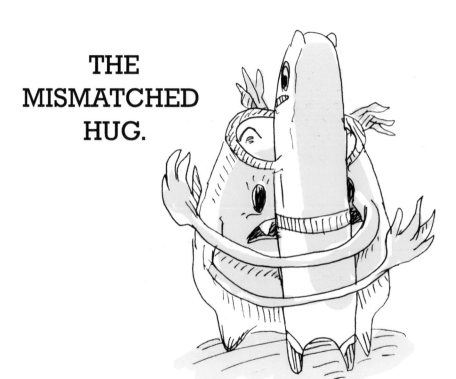

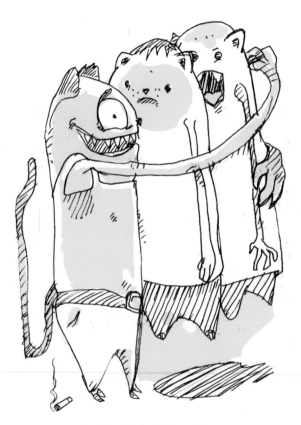

THE OVER
ACHIEVER HUG.

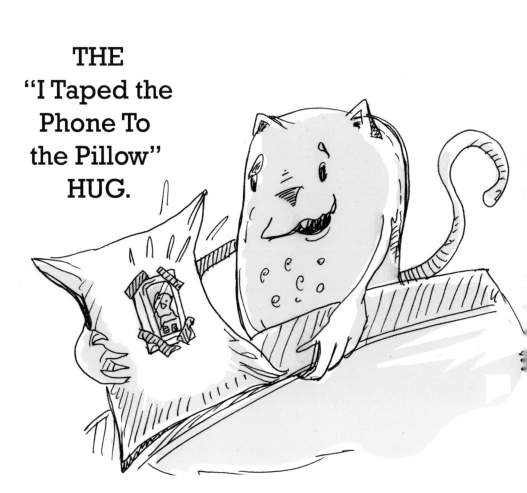

THE "I Taped the Phone To the Pillow" HUG.

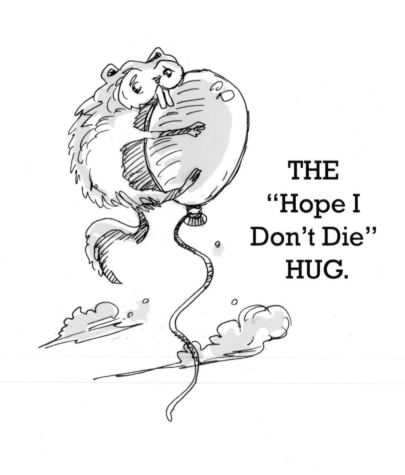

THE
"Hope I
Don't Die"
HUG.

THE
FEAR OF
COMMITMENT
HUG.

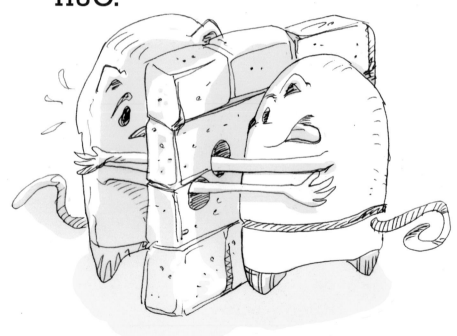

THE
TREE
HUG.

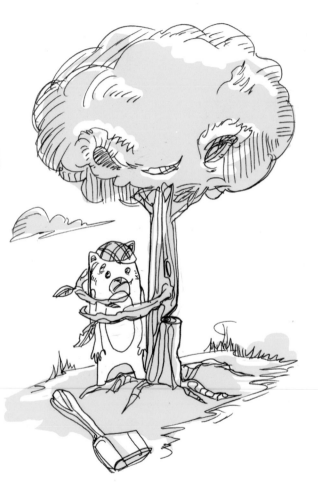

THE
TAG TEAM
HUG.

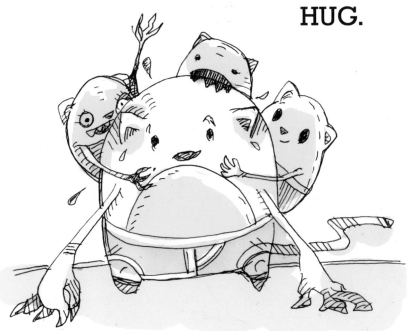

THE
SLOWLY
CONSUMING
THE WORLD
WITH MY
CUTENESS
HUG.

THE
"I Don't
Understand
The Meaning
of The Word"
HUG.

THE
"I Now Know
What You Had
For Lunch"
HUG.

THE EXCUSE TO SEE THE CONCERT BETTER HUG.

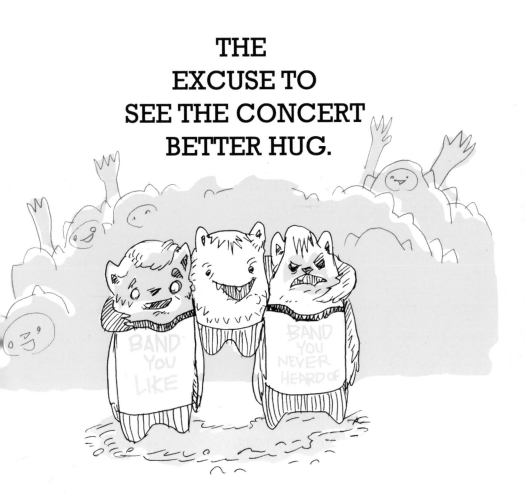

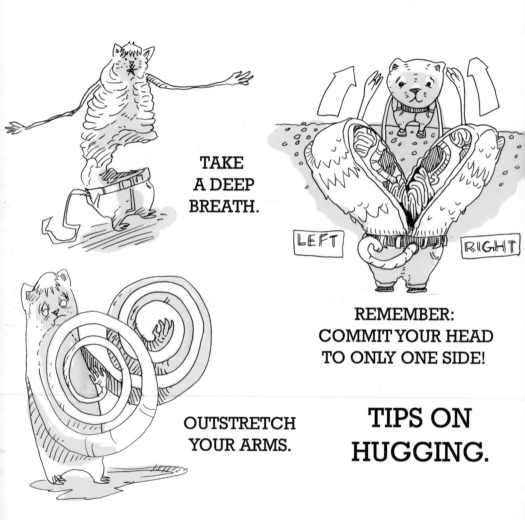

TAKE
A DEEP
BREATH.

LEFT RIGHT

REMEMBER:
COMMIT YOUR HEAD
TO ONLY ONE SIDE!

OUTSTRETCH
YOUR ARMS.

TIPS ON
HUGGING.

THE
"Take the
Photo
Already"
HUG.

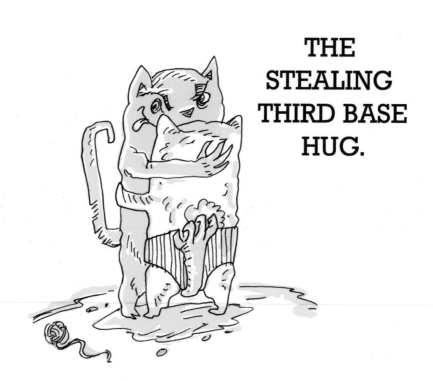

THE
STEALING
THIRD BASE
HUG.

THE "Whatever Works For Us" HUG.

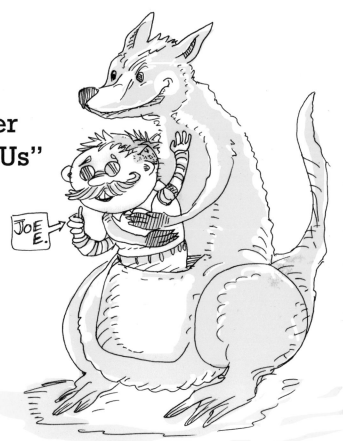

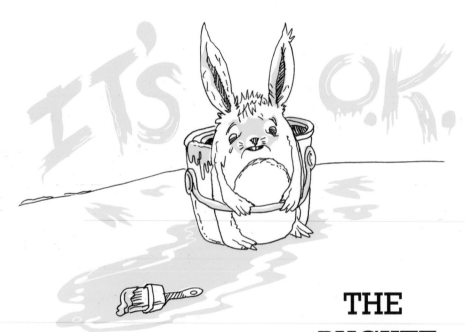

THE
BUCKET
HUG.

THE
NEW
HEADPHONES
HUG.

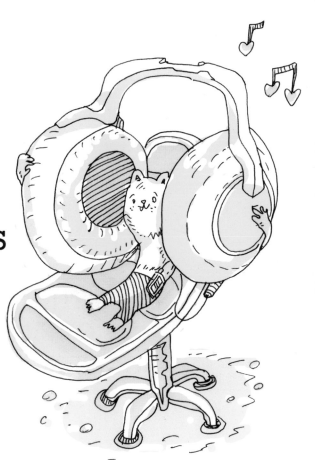

THE
OVER
COMPENSATING
HUG.

1st
ATTEMPT

2nd
ATTEMPT

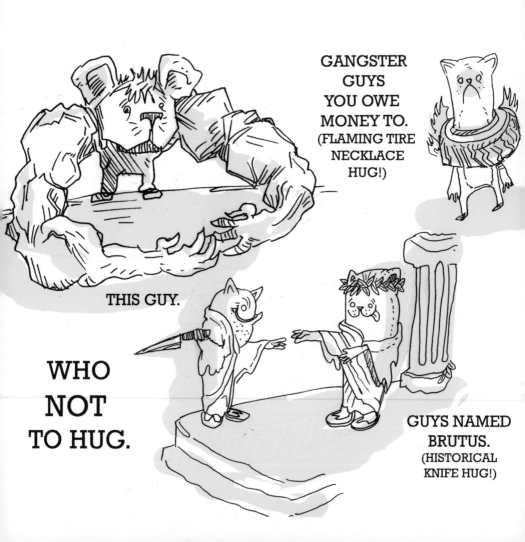

THE BALL OF HUG.

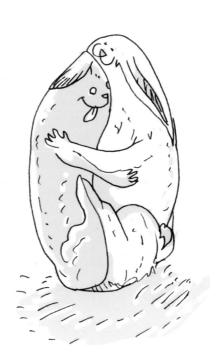

THE ISLAND OF UNREQUITED HUGS.

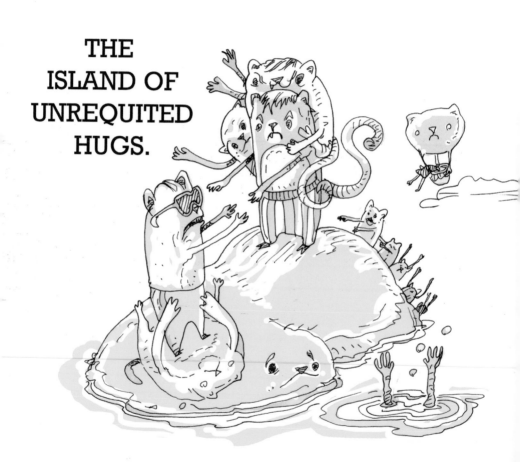

THE "Mr. Gropy" HUG.

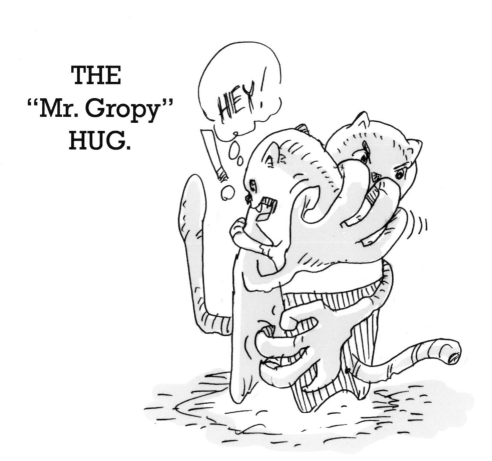

THE
SCIENTIST
WITH INTIMACY
ISSUES HUG.

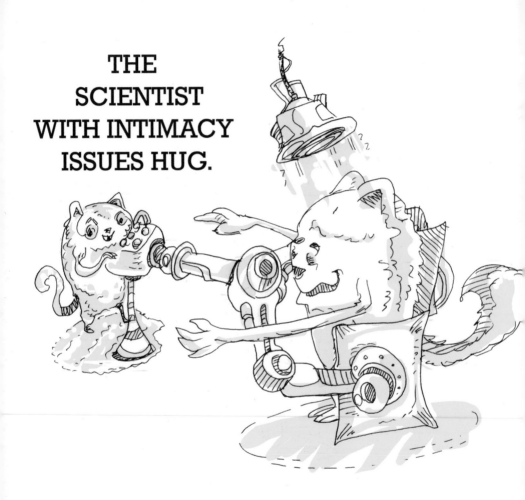

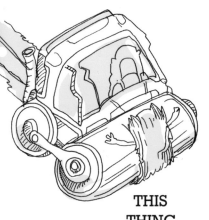

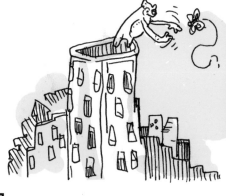

THIS
THING.

WHAT
NOT
TO HUG.

BUTTERFLY.

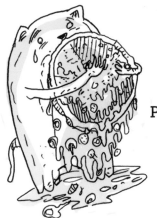

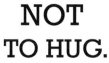

PEPPERONI
PIZZA.

NOW
WITH 100
BLADES!

MACH ∞

SHAVING
MASCOT.

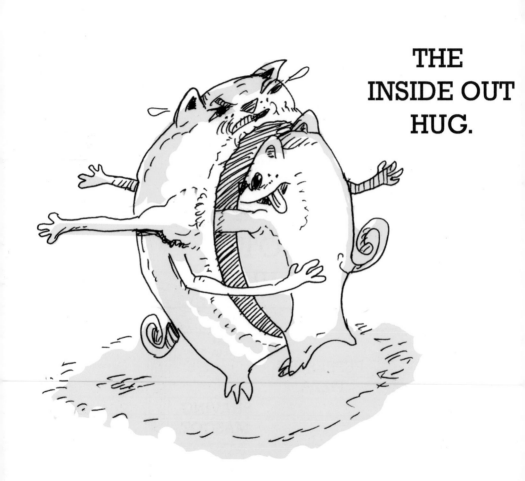

THE
INSIDE OUT
HUG.

THE "Comes with Baggage" HUG.

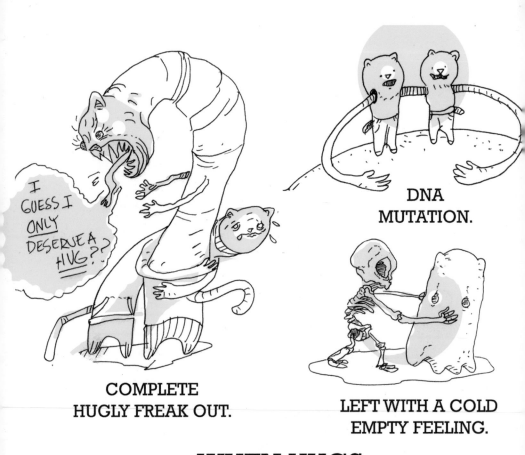

THE
SAYING
GOODBYE TO
LAST YEAR'S
PHONE BOOK
HUG.

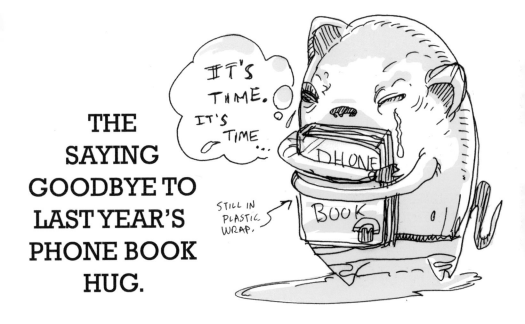

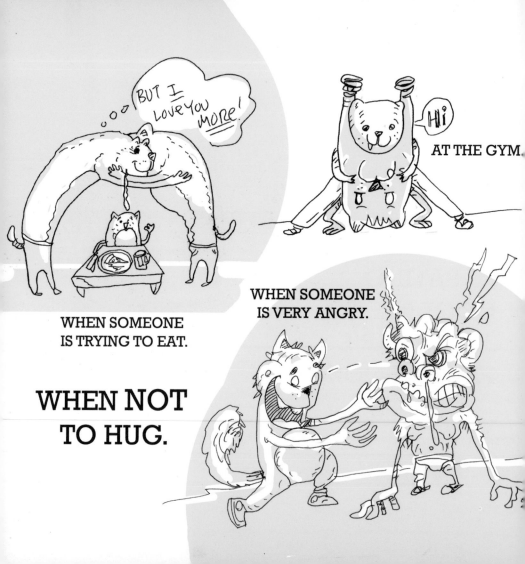

THE
NAPOLEON
HUG.

ONE
APATHETIC
ARM.

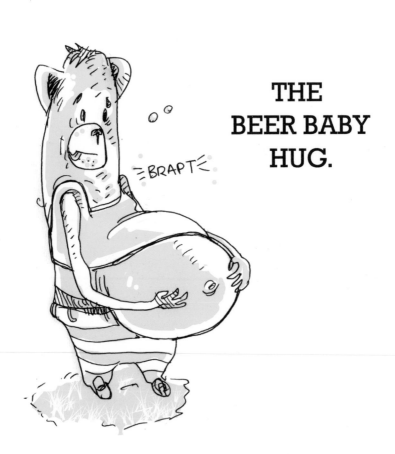

THE
BEER BABY
HUG.

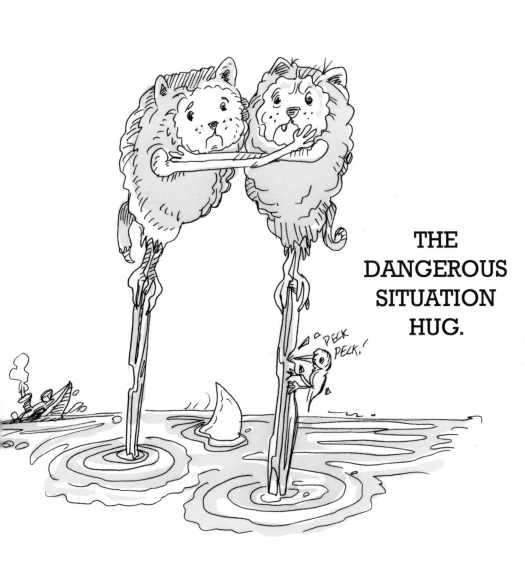

THE
DANGEROUS
SITUATION
HUG.

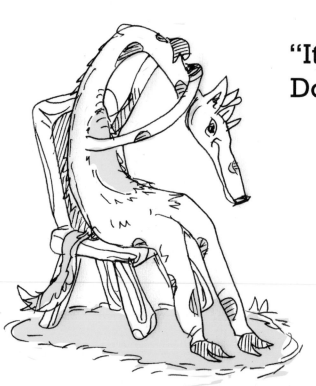

THE
"It'll Have To
Do For Now"
HUG.

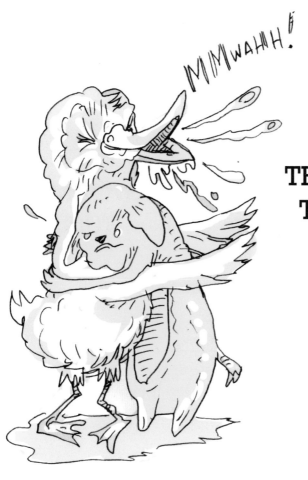

THE DUCK
THE KISS
HUG.

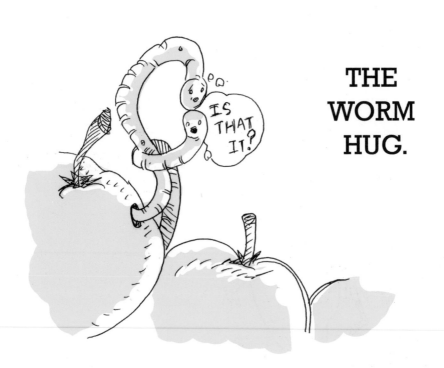

THE
WORM
HUG.

CLAMP
TYPE THINGS.
(STERILE)

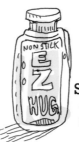

SALVE.
(NON-
STICK)

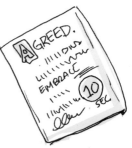

SIGNED AGREEMENT.
(WITH HUG DURATION
PRE-DETERMINED)

THE
NECESSARY
TOOLS
FOR
HUGGING.

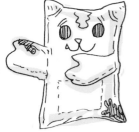

(PRE-STAINED)
PRACTICE
PILLOW.

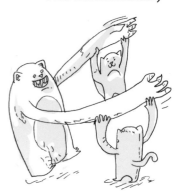

SECOND
LAYER OF SKIN.
(NEATLY FOLDED)

ASSISTANTS.

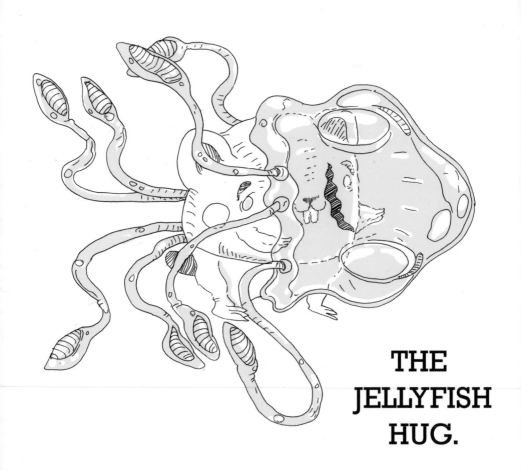

THE
JELLYFISH
HUG.

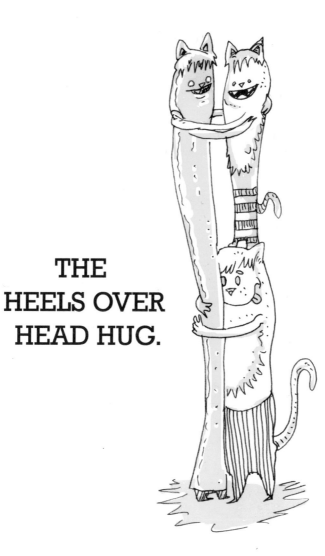

THE
HEELS OVER
HEAD HUG.

THE
NOTHING CAN
STOP US HUG.

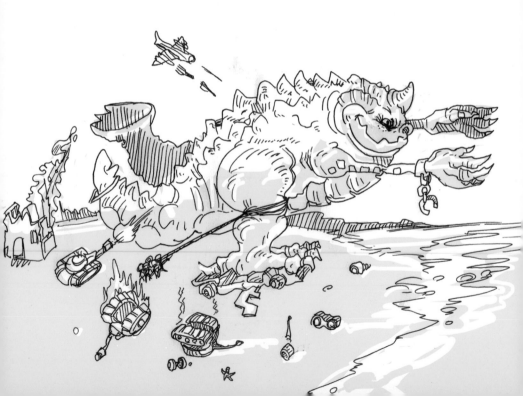

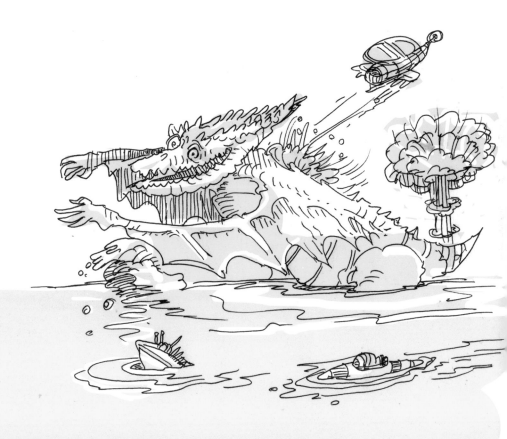

THE
SOCIAL MEDIA
HUG.

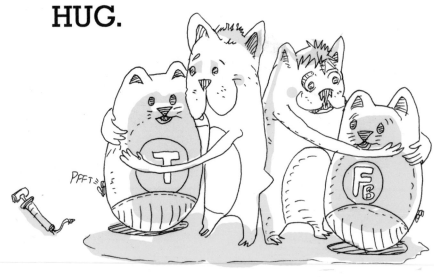

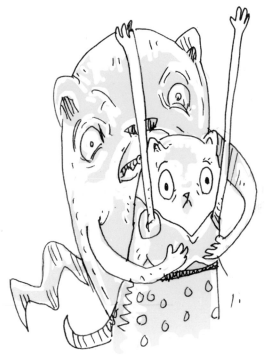

THE
"I Thought
You Were
Someone Else"
HUG.

THE
HARD TO
GET HUG.

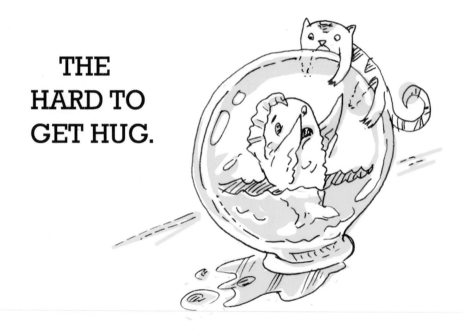

THE CRANE/NOSE HUG.

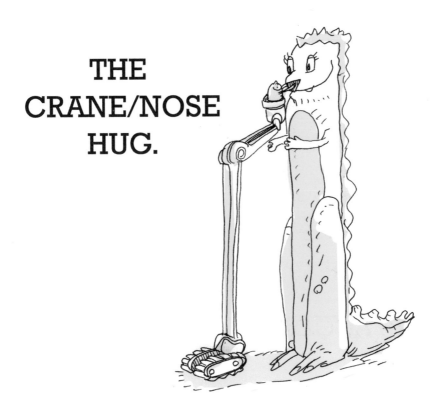

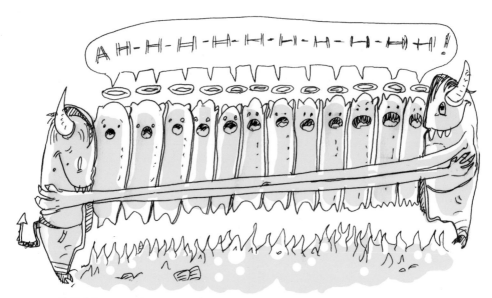

THE ACCORDIAN of SOULS HUG.

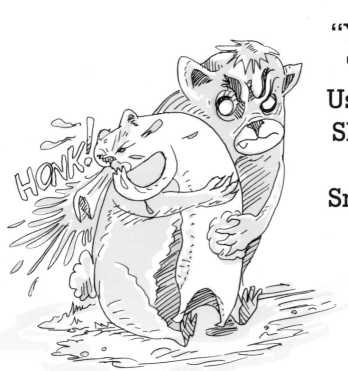

THE "You Are Totally Using My Shoulder As a Snot Rag" HUG.

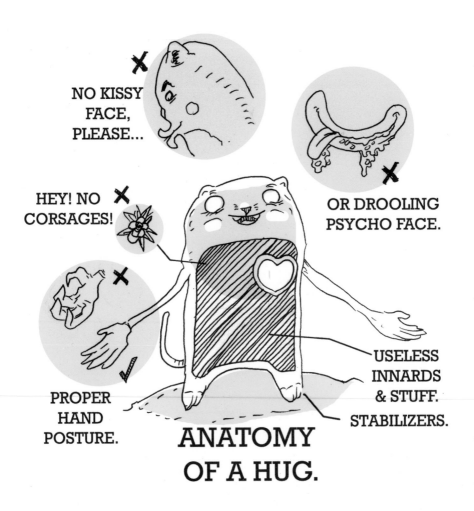

THE
ALL TOO
LONG
HUG.

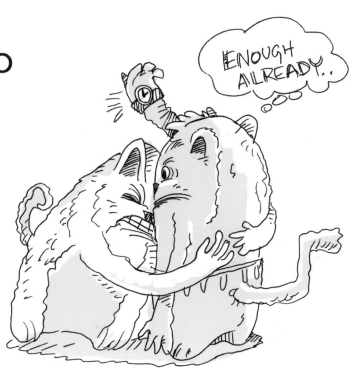

THE
SLOW HUG
DAY.

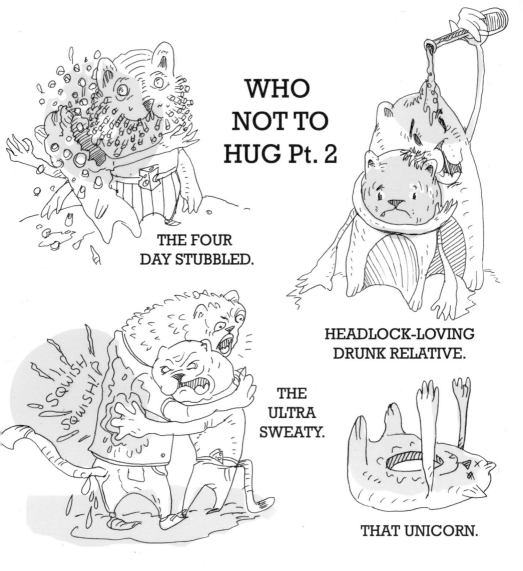

WHO
NOT TO
HUG Pt. 2

THE FOUR
DAY STUBBLED.

HEADLOCK-LOVING
DRUNK RELATIVE.

THE
ULTRA
SWEATY.

THAT UNICORN.

THE
"I Don't Want
To Leave My Bed"
HUG.

THE COLD FISH HUG.

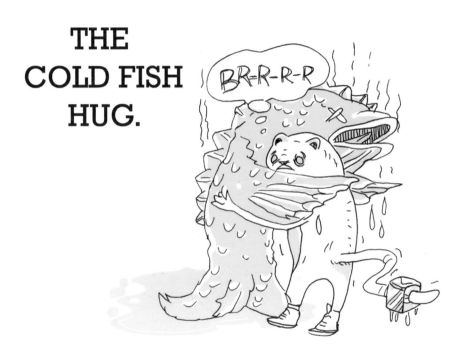

THE
UNDER
THE TABLE
HUG.

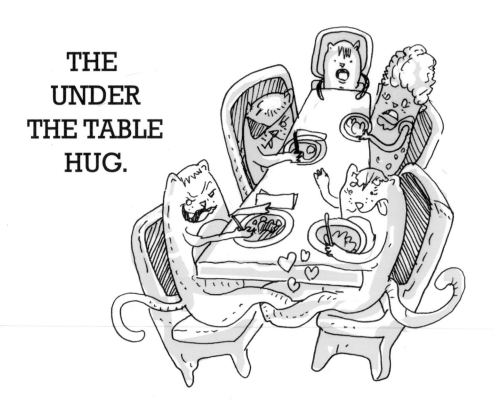

THE
"So You're
Going to
Act Like An
Annoying
Mermaid
Now"
HUG.

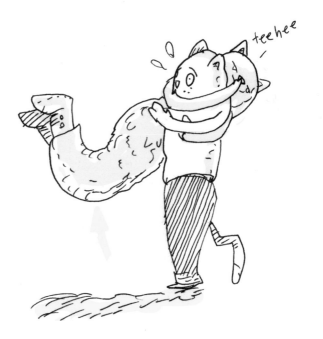

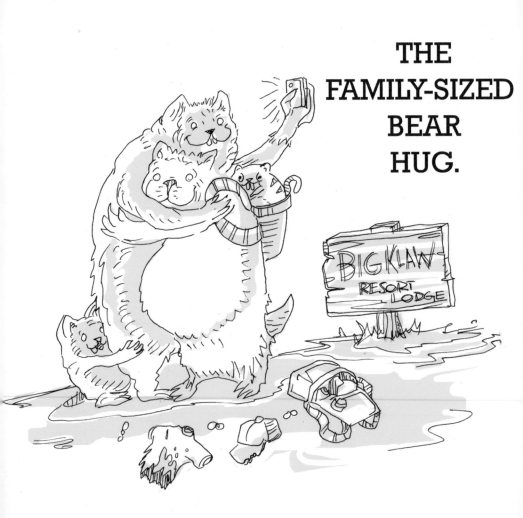

THE
FAMILY-SIZED
BEAR
HUG.

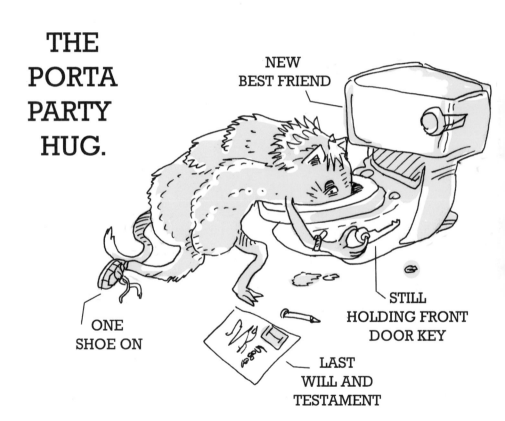

THE
PORTA
PARTY
HUG.

NEW
BEST FRIEND

ONE
SHOE ON

STILL
HOLDING FRONT
DOOR KEY

LAST
WILL AND
TESTAMENT

"I Can't Shake This Damn Rainbow" HUG.

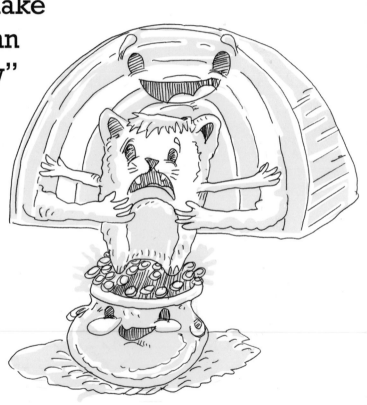

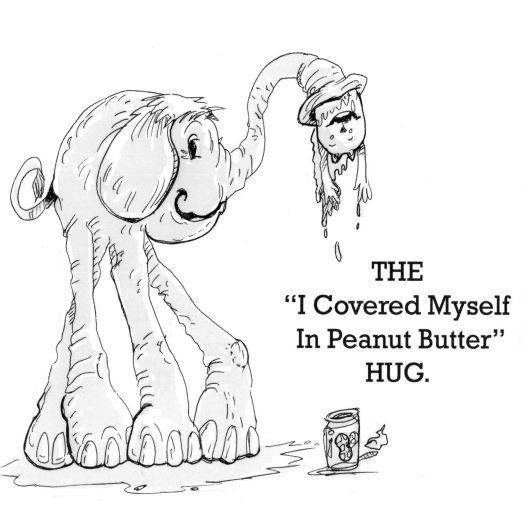

THE
"I Covered Myself
In Peanut Butter"
HUG.

THE
"HA HA!
Look at All Those
Lonely People"
HUG.

THE
KUNG-FU
MASTER
HUG.

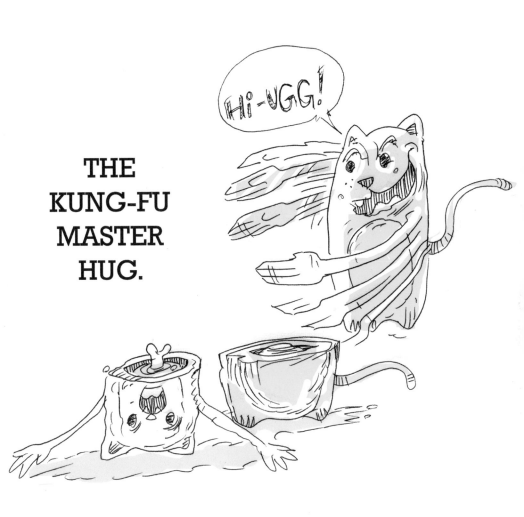

THE
HUG OF
UNCERTAIN
VICTORY.

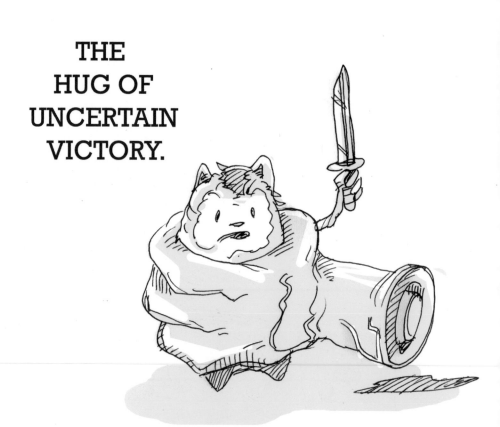

THE
"You
Complete
Me"
HUG.

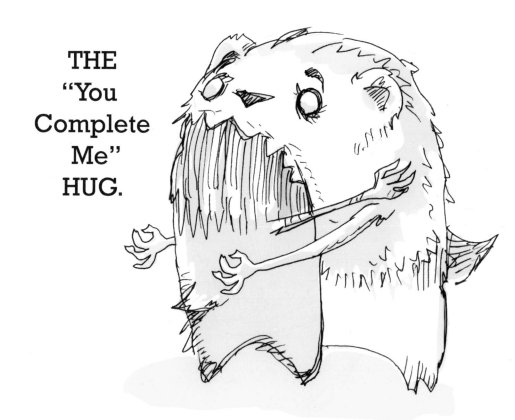

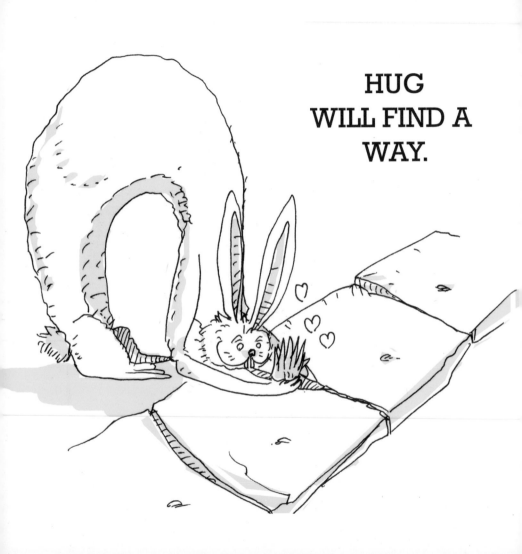

HUG
WILL FIND A
WAY.

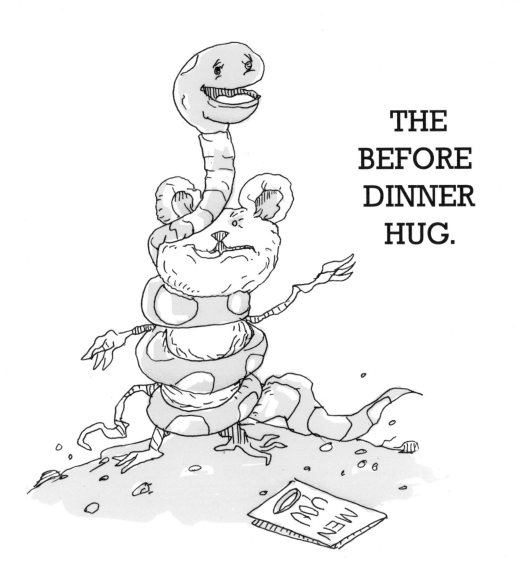

THE
BEFORE
DINNER
HUG.

THE OVER
QUALIFIED
TO HUG.

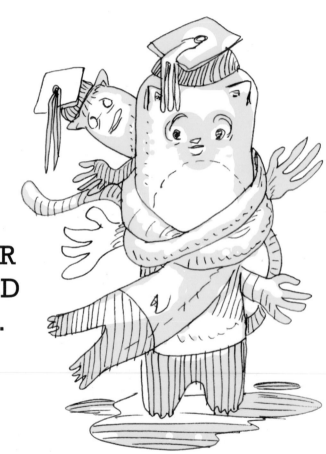

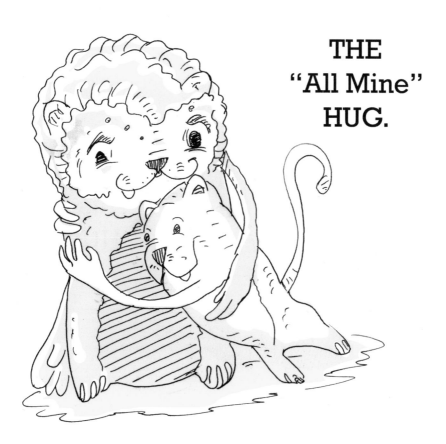

THE
"All Mine"
HUG.

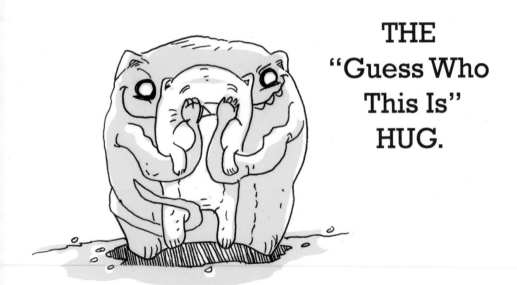

THE
"Guess Who
This Is"
HUG.

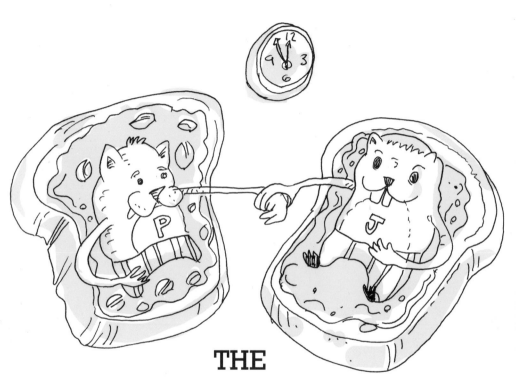

THE
WAITING FOR
LUNCH TIME
HUG.

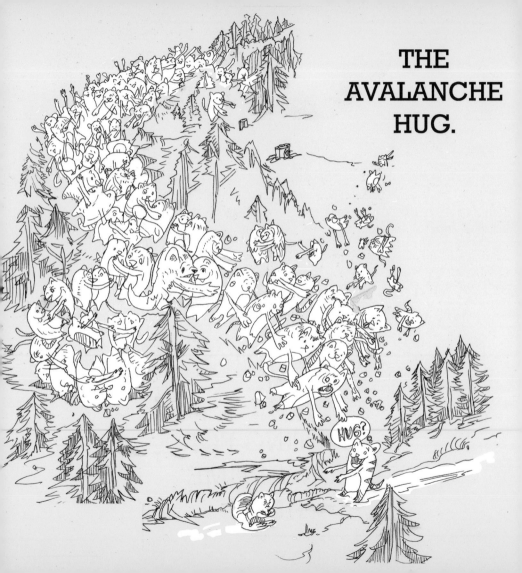